POSTING

BOX

D. S. F.

USTAR

letters from england

signs and lettering

Peter Ashley

ENGLISH HERITAGE

AN ENGLISH HERITAGE POCKET BOOK

p 1 **Yarmouth** ISLE OF WIGHT
'Stout gauge metal plates, deeply engraved and filled with Vitreous Enamel in colour to suit customers' requirements'. Brilliant Signs Catalogue, 1939.

p 2 **Kitchen Wall** NORTHAMPTONSHIRE
Detail from a Colman's sign, in their unmistakeable mustard yellow. A helpful corner stamp tells the date of its manufacture, April 1924.

Published by English Heritage, Kemble Drive, Swindon SN2 2GZ
www.english-heritage.org.uk
English Heritage is the Government's statutory adviser on all aspects of the historic environment.

© Peter Ashley
Images © Peter Ashley.

First published 2004

ISBN 1 85074 912 4

Product code 50962

British Library Cataloguing in Publication data
A CIP catalogue record for this book is available from the British Library.

Edited by Val Horsler
Page layout by Peter Ashley and Chuck Goodwin
Cover by Peter Ashley

Printed by Bath CPI

contents

introduction

Good lettering in the environment was once the preserve of craftsmen: the lettercutters and signmakers who enriched daily life with their art. The range and beauty of their work extended alphabets out from the printed page to grace tombstones and memorials, to identify shopkeepers and to advertise services. Railways guided their passengers with station signs that perfectly complemented their architecture, and the signwriter traced out his letters against the carefully considered paint schemes of buses, lorries and delivery vans. Fishing boats and canal boats developed an unconscious style that echoed folk art origins and public houses marked their facilities with windows of shaped glass and hot strips of lead. Even fishmongers and market stallholders boldly wrote their prices and weights in a bulbous chalk freehand on blackboards. Exact incisions into slate, brushstrokes on brickwork, gold leaf on glass, paint on wood, vitreous enamel on iron; tradition and craft combined to give silent voice to the messages of trade, commerce and transport. Everywhere there was pride in a job well done.

Happily, much good lettering still exists. A walk round a country churchyard, particularly near the church itself, will reveal lettering cut by hand that is as beautiful as the title pages of antiquarian books. There are lettercutters who still work in stone and slate, signmakers who continue to hand-paint shop fascias or inn signs, and in maintenance yards those with a deft touch are still 'ticking-in' lettering on the sides of canal boats. But we'll be lucky if we see decent station signing outside of a preserved railway line and vehicle liveries of any quality will usually be lined up at a vintage transport rally. Out on the roads we are assailed by a mass of bland messages slapped on to indifferent vehicles, a situation not helped by the fact that most vans are in what the paint card probably calls 'Off-the-Shelf White'.

Signing suffers because of the way we use the new technology. Anyone who can stare at a screen and shuffle a mouse about is now an instant designer, but the problem comes when computers are used as a substitute for thinking, ignoring the thought processes that were inherent to craftsmen who lettered and drew by hand. The computer is a wonderful tool, providing it is used as just that – a machine to speed things up, to give options, to try things out. But there must also be an understanding of the context in which ideas will be seen. A bus livery, that might just look passable on a laptop in a boardroom presentation, can look grotesque when it's blown-up to 20 feet high and driven around next to trees and cows.

We need to look at good signing again with a fresh and appreciative eye. We are fortunate that we have a champion for these sometimes neglected subjects in English Heritage, who continually encourages us to see beyond the obvious and who forms partnerships with those responsible for so much in our visual environment. But equally, it's very important for all of us to stand up against the misguided thinking that treats this century as year zero. The character and traditions of our past are what make us, and should continually inform our decisions for the future. After all, we live in a time when we are quite literally swamped by words, so much so that there is a grave danger of them being devalued and rendered illegible. (Think about mobile phone 'txtng'.) Lettering is the suit of clothes that brings the wording on signs to life, and used with thought and care it can help us to stop drifting remorselessly into a depressing homogeneity.

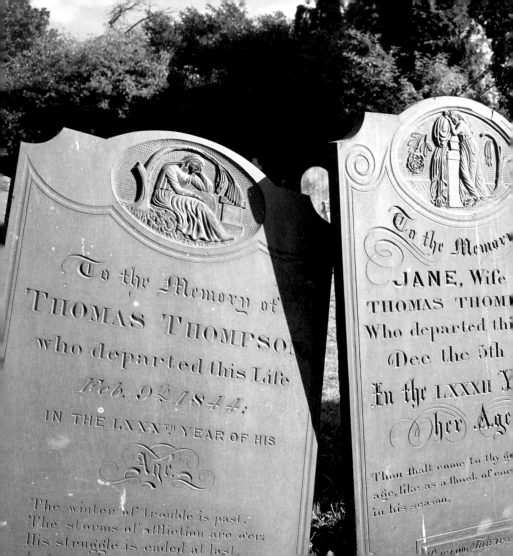

To the Memory of
THOMAS THOMPSON
who departed this Life
Feb. 9th 1844:
IN THE LXXXth YEAR OF HIS
Age.

The winter of trouble is past,
The storms of affliction are o'er;
His struggle is ended at last.

To the Memory
JANE, Wife
THOMAS THOMP
Who departed thi
Dec the 5th
In the LXXXII Y
her Age

Thou shalt come to thy g
age, like as a shock of cor
in his season.

grave words

Churches and their churchyards are one of the best places to see the lettering styles of a distant past. The ranks of leaning tombstones not only give epitaphs and the details of family life and death, but also art lessons in the individual styles of the letter-cutters and carvers who carefully guided their sharpened tools across stone and slate surfaces. There will be regional differences of material, local fashions in lettercutting and evidence of the continual experimentation with the new alphabets that arrived in the latest edition of the printer's type book.

It is very rare to find a tombstone dated before 1600 and the demand for durable memorials is even passing away from our own age. Graves are still identified by markers, but most now appear to be highly polished slabs of black granite with machine-produced names, dates and sentiments mechanically let into the surface.

Aldwincle NORTHAMPTONSHIRE

Slate tombstones line up in the quiet churchyard of All Saints. These are very impressive monuments, hardly worn since their positioning here in the mid-19th century and still retaining a relatively simple typographic style in the face of the florid, over-sentimentalised gothic that was gaining popularity.

THE MEMORY OF

LIZABETH,

WIFE OF

RGE ROBINSO

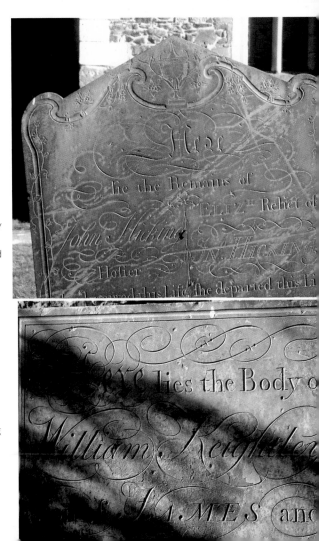

> **Newtown Linford** LEICESTERSHIRE
Amongst the pastoral acres of
Leicestershire, a geological surprise
occurs to the west of the county town.
An area of volcanic igneous rock only
seven miles by four in extent completely
alters the landscape. Hedges become
stone walls and a very distinct building
stone replaces the Leicestershire red
brick. Two quarries, now deep and deadly
pits in Swithland Woods, produced a
beautiful, much sought after slate – found
on roofs, cut to form window sills,
doorsteps, gate posts, cheese presses
and of course gravestones. Newtown
Linford church has them in abundance,
but they quickly found a market all over
the county and far beyond. These two
headstones are text book examples of
the master lettercutter's art.

< **Yardley Hastings** NORTHAMPTONSHIRE
A slightly more purple variety of slate,
with the simpler letterforms slowly being
overtaken by ivy in the churchyard of
St Andrews.

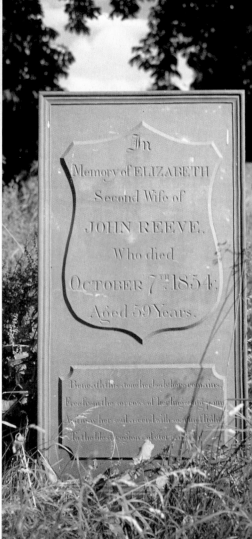

^ Great Tew OXFORDSHIRE

Another county, another stone, this time the gingerbread limestone of north east Oxfordshire with lichen and mosses adding a patina of age over the surfaces.

> Owston LEICESTERSHIRE

This is without doubt one of my favourite country churchyards, a place for quiet contemplation in the long grasses growing around the gravestones that are, of course, so easy to date. I particularly like the elegant shield that contains the lettering on Elizabeth Reeve's headstone.

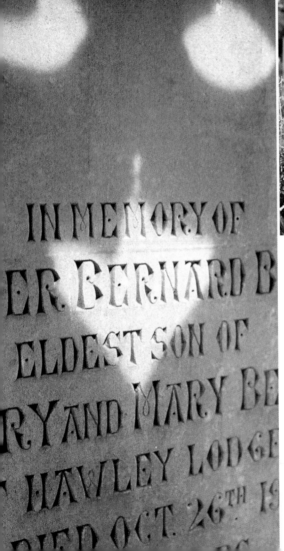

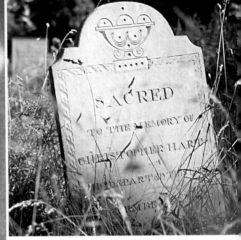

∧ **Owston** LEICESTERSHIRE
The mid-Victorian headstones for
Christopher Hart and his wife have
devices set into the rounded tops that
remind me of the decorations much loved
by the painter and designer Eric Ravilious,
who flourished 80 years later.

< **Brookwood Cemetery** SURREY
These vast acres of Surrey pines and
laurels provide letter hunters with almost
countless examples of the craft, most
notably, of course, Victorian. Classic letters
are used here the Bent memorial, one
of the most Gothic of monuments in the
cemetery, which now sadly suffers from
the terrible twin deprivations of neglect
and mind-numbing vandalism.

REVᴰ ROBERT LINTON,

1832.

In Memory of
HN SOUTHWELL
departed this Life

dbore gen qui
yt duo decimo
e Octo Anno Dñi

Fotheringhay NORTHAMPTONSHIRE

< Inside the church of St Mary and All Saints are tombstones let into the floor. Here the inscriptions will not suffer the incessant scouring from inclement weather, and only the shoes of the clergy and parishioners will gently buff this elegant lettering that is as tight and disciplined as a piece of late Georgian typography on a printed page.

< Equally impressive is this slightly posher Southwell memorial slab of 1851.

Kings Cliffe NORTHAMPTONSHIRE

< A little piece of polished Latin in All Saints church. Flourishing with loops and swirls it is as fresh as the day it was put up on the wall. In 1688.

Compton SURREY

A complete contrast up on a sandy hilltop in Surrey is the cemetery chapel built by Mary Watts in memory of her husband George Frederic Watts, the painter and sculptor. It is an orange brick and terracotta extravaganza so stuffed full of Celtic and Art Nouveau references that the 'W' monogram on the wall is almost subtle by comparison.

writing on the wall

As the Victorian era progressed, brick and
stone surfaces were eagerly utilised for
painting-up advertisements and signs.
The durability of some of them is quite
astounding: faded and distressed
advertisements still whisper their messages
on the end of terraces and up on painted
walls. Sometimes the blank canvases of
blank walls were tempting enough for
proprietors to go the whole hog and
create works of art in tiling and raised
letters.

< **Thorpe Langton** LEICESTERSHIRE
A far better effect has been gained here on
this pub wall by applying the lettering
directly to the surface, rather than just fixing
up a wooden amenity board. It also shows
how computer-generated lettering can
work well if used with a little care and
thought.

<< **Market Harborough** LEICESTERSHIRE
End gables are ideal for big statements.
Passing traffic can't miss them and here
next to the River Welland in Market
Harborough is a superb example that still
advertises the store that stands behind it.

17

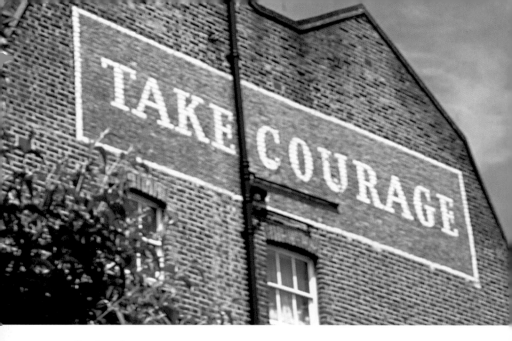

Southwark LONDON SE1

I first saw this slogan (as it would then have been called) in the 1950s, and thought what a very clever thing it was. I think it was around during the Second World War, so how good was that. It's still with us, and the reason is simple. Courage was a London brewer and their beer was no here today, gone tomorrow fad. Even their brewery was the closest you could get to Tower Bridge. So they told everybody about it, literally from the roof tops, with long term 'media' as we would now say. You'll find it everywhere, particularly on end gables like this one in Park Street: a kind of London mantra that still eggs us on. Courage has not yet abandoned us, but whatever happens their signs will live on, flickering in neon on Shooter's Hill or Rotherhithe, and up in the sun on a Southwark wall.

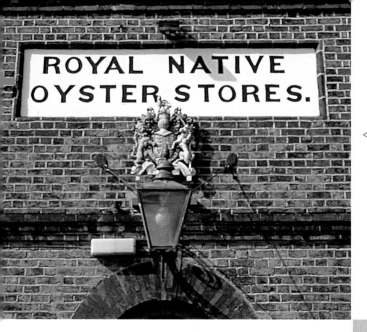

< **Whitstable** KENT
No-nonsense sans-serif
letters for the atmospheric
oyster stores, crisply
painted on its own inset
panel and including an
example of the once
fashionable use of an
emphatic full stop.

> **Bridport** DORSET
Directing the way to rows of very desirable volumes in a Bridport
bookshop is the ubiquitous index finger. Immaculately cuffed hands
are a signwriter's stock image, taken from the pages of typefounders'
catalogues. Designer Alan Fletcher is a collector and displays 132 of
them in his breeze block of a book *The art of looking sideways*.

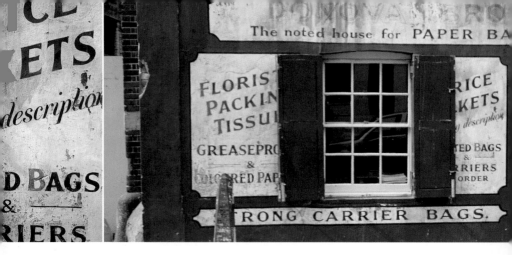

Spitalfields LONDON E1

This is the sort of signing that makes those who love these things jump up and down on the pavement. Donovan Bros supply everything needed for wrapping up and carrying market produce and much else besides – paper bags, carrier bags, florists' tissue paper, butchers' greaseproof paper. They were ideally placed to serve Spitalfields when it was one of the last wholesale markets still surviving in London, but with the inexorable change in the area to loft living and calling milky coffee 'latte', Donovan Bros have fled out into Essex.

FLORIS

PACKIN

TISSU

GREASEPRO

&

> Greenwich LONDON SE10

Very heartening is this recent example of lettering on a corner curve in the centre of Greenwich that shows care and consideration for the scale and proportion of the building.

⌐ Stamford LINCOLNSHIRE

This building in Bath Row is a perfect 1832 example of a communal bath house, now only an exterior with this bold black on cream label painted directly on to the pale limestone. It was converted into a house, which helped to conserve its integrity, but I hope the lettering is listed along with the building, so that if it becomes a beauty parlour it doesn't get changed to something like '*Jackie's*'.

∨ York

Who now can testify to the health-giving properties of a nightly dose of Bile Beans? I suspect that some examples, like this one on a wall in York, are so part of local landscape that they regularly get repainted.

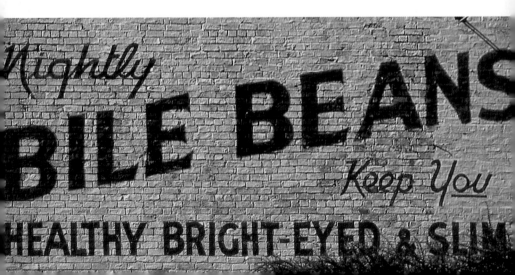

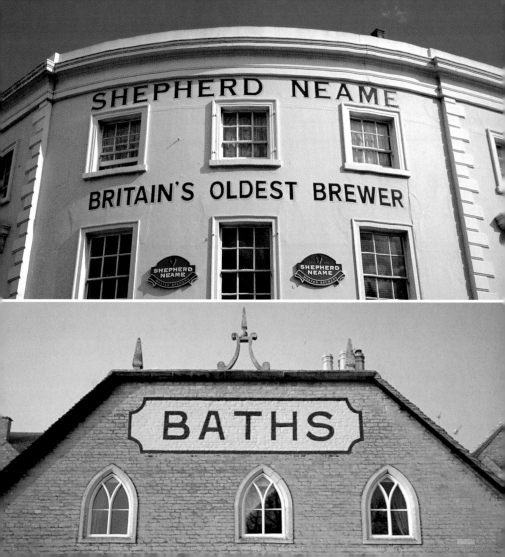

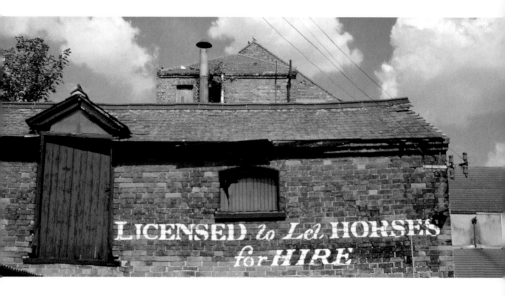

Bedford

Here is a reminder of the days when horses were the prime movers of people and goods, and horses meant a wealth of businesses dedicated to housing and maintaining them. I suppose this little brick building was the equivalent of both taxi rank and car hire office, but three weeks after I'd poked my camera over the wall to photograph this unexpected survivor it had gone, destroyed in a fire.

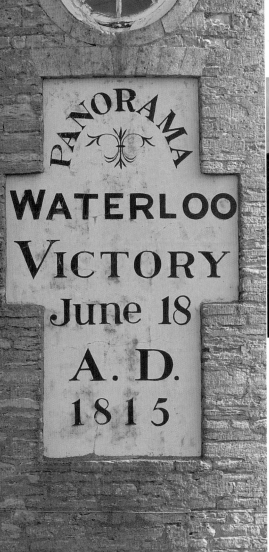

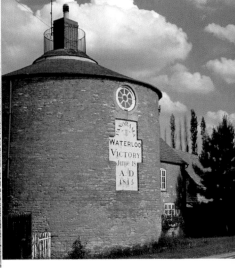

Finedon NORTHAMPTONSHIRE

I admire this plain early 19th-century lettering
on the Wellington Tower, built to commemorate
victory at Waterloo in 1815. It is said that
Wellington himself gave a lecture on the battle
from the viewing platform, using local landscape
features to explain his strategies.

MOULDS JIGS TOOLS & DIES

∧ Birmingham

The Jewellery Quarter in Birmingham appears to be fast disappearing under the polished wooden flooring of bars where silent girls serve men in black suits who drink straight out of bottles; so it's very reassuring to go round the corner and find a block of lettering as uncompromising as this. The factory does what it says on the wall, but it could equally be the life story of an overalled Brummie in the machine shop.

> Spitalfields LONDON E1

You can tell, on this beautifully-lettered green-tiled wall, that it's the real thing by looking closely at the white paint where you can see the deft brush strokes. The crispness of the edges is possibly due to them being sharpened off with a tiny scalpel blade when dry, but of course the signwriter could just have been that good and got it right first time.

HOT ME
ALL DA
VERY SER
EL: 377 62
HES AT
ARTILLERY LANE
ARTILLERY PASS
CRISPIN ST. E.1

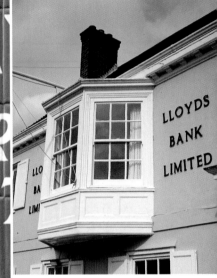

∧ **Yarmouth** ISLE OF WIGHT
An unregarded but perfect example
of a corporate style being subdued
so that the integrity of the building
is maintained. Bronze metal cut-out
letters were available in sizes from
2 to 24 inches, with no charge
made for full stops or commas.

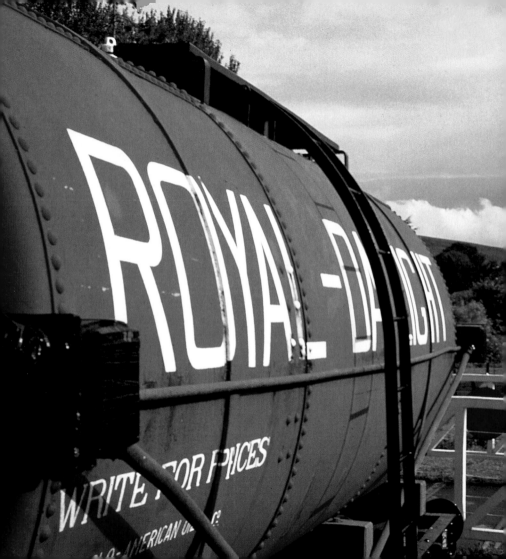

railway signals

The arrival of the railway brought truck loads of signs and lettered artefacts in its wake. Stations needed to be identified to passengers, locomotives named, truck owners identified and ladies directed to their very own waiting rooms. Myriad individual railways developed their own styles throughout the 19th century, but the clearest identities emerged in 1923 when the government ordered the retention of the 'Big Four' companies brought together for the Great War. Passengers quickly recognised the new styles of the GWR, LNER, LMS and the Southern. On nationalisation in 1948, colour-coded regional signing was introduced that worked superbly well until summarily swept away in the 1960s, to be replaced by what were possibly the most boring station signs ever produced.

< **Staverton** DEVON
Private owner wagons were moving poster hoardings, and one of the most effective was Anglo American Oil's Royal Daylight tank wagons that quickly became iconic Hornby models.

> **Hampstead** LONDON NW3
Art nouveau lettering set into the green faience ticket window surround at Hampstead Underground station.

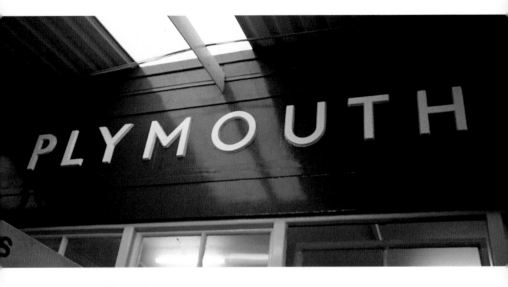

∧ **Plymouth** DEVON

Simple cream wooden letters on a deep green timber fascia, this typeface was
originally designed by Eric Gill, who was closely associated with the LNER over in
the east, but whose work is seen here in the west of England in Plymouth. It is
evidence of the universal appeal of Gill as a clear uncluttered typeface, ideal for
portraying information (as indeed it does in this book.

> **Manningtree** ESSEX

This isolated Essex station boasts not only a proper *Brief Encounter* refreshment
room instead of a weary franchise, but also this waiting room door with its sand-
blasted glass panel containing well-drawn letters combined with oversized initial
capitals and a decorative border.

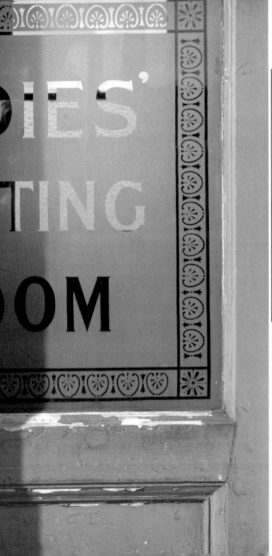

DIES'
TING
OOM

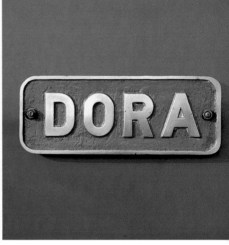

∧ **Wansford** CAMBRIDGESHIRE

Locomotive nameplates weren't
designed: they were just as much a part
of the technical drawings as the firebox
or buffer beam, an intuitive natural
extension to the engineer's skill. Dora
steams up and down the Nene Valley
Railway near Peterborough.

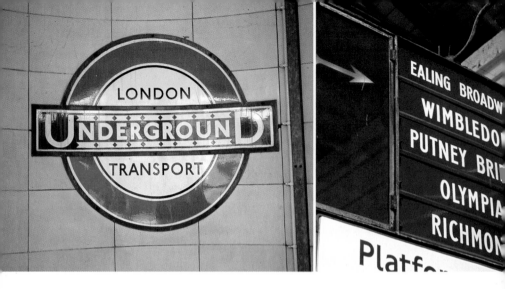

∧ **Aldgate East** LONDON EC3

The London Underground roundel is one of the most recognisable symbols in the world. Along with red Routemaster buses and black taxicabs, it is a perfect shorthand for the metropolis. In 1908 the red circle was a filled-in disc with a dark blue name bar, but eight years later Frank Pick, the London Transport maestro, asked Edward Johnston to redesign the 'bulls-eye' symbol. Johnston also gave us the sans serif type that so influenced Eric Gill and introduced the larger 'U' and 'D' to the logo, as seen here on the stairwell at Aldgate East.

↗ **Earl's Court** LONDON SW5

Unconsidered but very familiar signs up on the District line platforms at Earls Court. I have stood here at all times of the day staring up them waiting for the illuminated arrow to point in its friendly way to either Ealing Broadway or Richmond. I know they're scruffy and use a typeface not in the corporate identity manual but I do hope nobody removes them in a fit of rationalisation.

∧ **Gloucester Road** LONDON SW7

Many London Underground stations are faced
with these beautiful deep ruby-red (they called it
'sang de boeuf', or ox blood) glazed terracotta
tiles. Here at Gloucester Road they form a frieze
to take the station name.

< **Chalk Farm** LONDON NW1

Another ox-blood station designed by Leslie
Green, Chalk Farm opened in 1907, and in the
following year an early attempt at standardising
letterforms took place, resulting in these blue and
white tiles curving round the corner. The contrast
in colours works superbly.

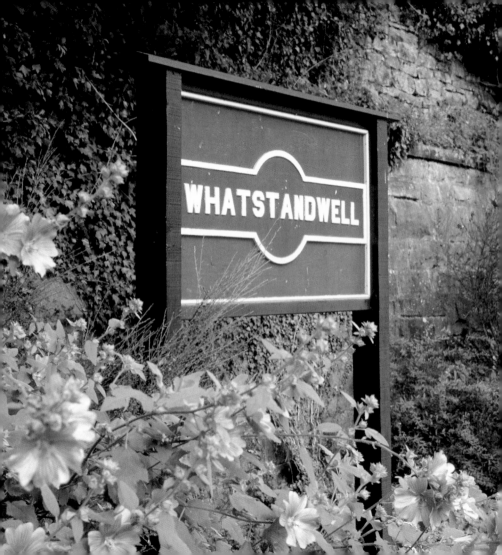

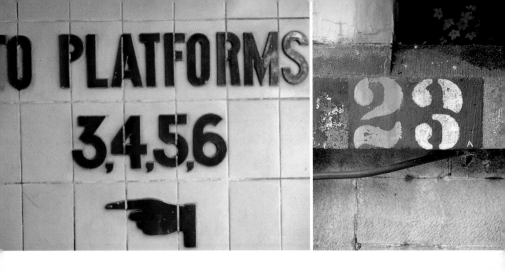

∧ **Exeter** DEVON

These GWR chocolate letters raised up from cream ceramic tiling at Exeter St Davids, together with another helpful pointing hand, give the impression that the GWR really cared for the passengers scurrying to catch their connecting trains to Halwill Junction or Budleigh Salterton.

⌐ **Crompton** DERBYSHIRE

A hurried, stencilled number identifies the bridge on the platform of this dark and spooky station. Hurried stencilling? The stencil used for the numeral three was placed upside down and back to front. Rust-staining from the footbridge above helps give the sign a vibrant palette of colour.

< **Whatstandwell** DERBYSHIRE

A far cry from the days of red Midland locomotives rushing through the stations and tunnels of the Derbyshire Peaks to the north, Whatstandwell station still clings on, but is now little more than a halt on a branch line that finally peters out in Matlock. On my visit, however, it could all still have been the 1930s, with a restored 'Hawkseye' name board painted in the Midland's crimson lake and cream.

Leicester

The London Road station was built by the Midland Railway in 1892. Part of its wonderful sense of swaggering style brought a series of oven-glazed art nouveau signs to the roadside exterior.

Dawlish DEVON

You know your holiday's started when you arrive here. The station perches just above the beach and you can have no doubt about where you are with this Great Western sign, with Egyptian Bold Condensed capitals shouting into your carriage.

Heckington LINCOLNSHIRE

They might be sun-faded and a bit rusty round the edges, but Heckington managed to hang on to its post-war British Railways 'totem' signs longer than most. Each region was distinguished by different coloured signing: Scotland was pale blue, the North West orange, the Midlands a deep red. Some colours seemed oddly appropriate to me as a child: brown and cream for the West (cows, clotted cream), green for the South (woods, downland) and the dark blue of the East for the sea of my holidays in Lincolnshire.

Adlestrop GLOUCESTERSHIRE

Yes. I remember Adlestrop / The name, because one afternoon / Of heat the express-train drew up there / Unwontedly. It was late June.

Was ever a station name so imbued with the sense of a fleeting moment so evocative of a train journey on a summer's day? The poet Edward Thomas must have looked out at this sign, or one of its companions, on the now vanished platforms. The Great Western station sign now presides over the bus stop in the village, and the full poem is thoughtfully engraved on a plate attached to another relic from the station, a platform seat with the original GWR monogram cast into its supports.

DAWLISH

HECKINGTON

ADLESTROP

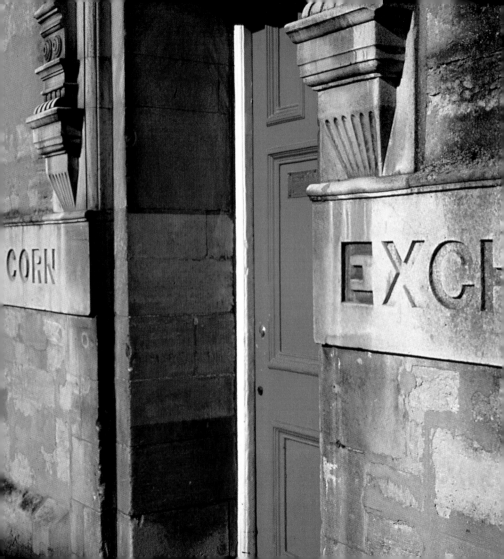

set in stone

It's another thing the Romans did for us. The letterforms on Trajan's Column are the basis, however tenuous, for an alphabet that has continued in use until this new century. Times Roman (it was the typeface for the newspaper) was the alphabet I struggled to draw as an apprentice commercial artist in the 1960s, having dreadful things happen to me if I strayed from the rules of its strait-jacket. Only masochists draw it much these days, but the whole idea of cutting lettering into stone in a variety of typefaces still endures. There's a growing fashion for mottos and bits of poetry to be carved out for garden ornaments, which gives the craft much needed exposure and helps to keep it alive.

Thrapston NORTHAMPTONSHIRE

They don't exchange corn much these days in Thrapston, but this building's last use was as a sale room, so the sound of an auctioneer's hammer echoed for a while longer. Most stone cut lettering will be recessed into the surface, and this example is particularly powerful as it stretches out at eye level on each side of the main entrance. Of course the impact is considerably heightened when bright sunlight creates a defining shadow.

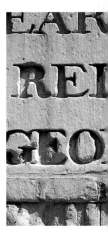

Lambeth LONDON

The ravages of time are clearly seen on this 1771 obelisk, now erected back in its original position at the junction of Westminster Bridge Road and Lambeth Road at St George's Circus.

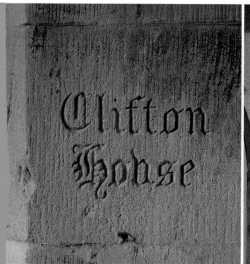
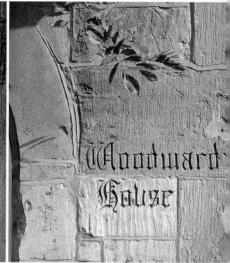

∧ ⌐ **Chipping Campden** GLOUCESTERSHIRE

This relatively unspoilt Cotswold town repays a slow walk around its streets of golden stone houses and inns to look at the wealth of fascinating detail, like these two house names cut into entrance quoins in a relaxed version of a gothic script. Chipping Campden was lucky to have the influence of the Guild of Handicrafts that settled here in 1902 and the presence of the motorcycling engraver F L Griggs who founded the Campden Trust in 1929.

> **Somerset House** LONDON WC2

The Civil Service War Memorial has been brought back to its original splendour during the restoration at Somerset House, and once again it's possible to see the inscription clearly incised in the creamy limestone, a perfect foil to the freshly painted flags.

THEIR NA
ARE RECOR
ON A SC
PLACED WIT
THIS COL

ALSO IN MEI
OF MEMBERS
THE CIVIL SEF
CADET BATTA

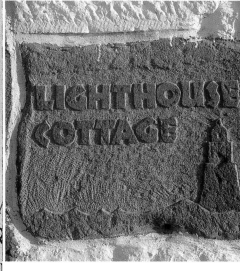

∧ **Cockersands** LANCASHIRE

A long lane winds through quiet fields
across to where the meeting of the
River Lune with the sea is marked by a
little lighthouse sitting out in the waves.
On the shore is a lonely cottage with
this delightful sign on its wall. The
stylised lighthouse in its choppy sea is
perfectly complemented by the raised
letters that must be in a typeface called
something like Fat Chap Extra Bold.

Maidstone & District MOTOR SERVICES LTD.

moving letters

There is a rich and lively tradition of signing anything that moves. It probably took off with stage coaches in the early 19th century advertising, the express services that took advantage of the newly-improved roads. The signwriter's art appeared on farm wagons and canal boats, and made a natural transition from shop fronts to trade delivery carts.

The advent of the internal combustion engine brought motor cars for the rich, but as soon as they evolved into more reliable and efficient vehicles they began to have commercial bodies fitted to them that offered inviting surfaces for messages. We have seen how the railways used signing, but soon the competition of motorised public transport arrived with liveries in many colours and lettering styles.

Chatham KENT

The amalgamation of bus companies in the 1970s into the National Bus Company resulted in the loss of many individual livery schemes. The relentless application of a corporate style gave us such anomalies as the once distinctive paint scheme of the Cheltenham operator Black & White being rendered in red and blue. We lost the local differences that were as individual as their respective landscapes and, although some survived, logotypes like this classic example for Maidstone & District Motor Services will now only be seen at rallies and in local museums.

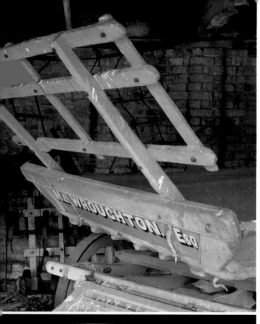

Five examples that show how lettering adapted to the changes in agricultural practice in a little over a hundred years, local signwriting slowly giving way to more commercial possibilities.

Boscobel SHROPSHIRE

< A traditional farm wagon resting from its labours in a barn at Boscobel House. The painting and signing of agricultural vehicles in the 19th century shared a common heritage with the folk art of travelling fairgrounds and canal boats.

Sacrewell PETERBOROUGH

∟ An unrestored example in the shade of a barn at the Sacrewell Farm Museum.

Wrotham KENT

↲ The steam locomotive found new expression away from railway tracks when traction engines revolutionised work on the farm, supplementing, but not replacing, the bucolic scenes of teams of horses ploughing. This uncompromising badge for Armstrong Whitworth would have been of great interest to farmers as they contemplated the new technology.

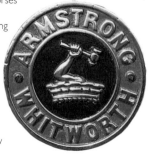

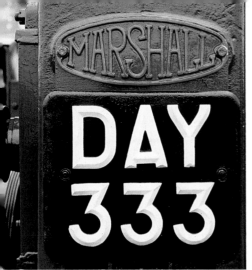

< **Leicestershire**

A Marshall 'M' tractor with its elliptical trademark cast into the front profile. The number plate is another benchmark design that has disappeared from everything but preserved vehicles. Its demise brought to an end an era of vehicle registration that started with Bertrand Russell queuing all night in London for the very first, 'A1'.

∨ Post-war manufacturers quickly recognised the marketing opportunities a tractor represented as it worked in the fields. Massey Harris couldn't have made a bigger splash in the countryside than with their yellow-wheeled bright red tractors and oversized logotypes.

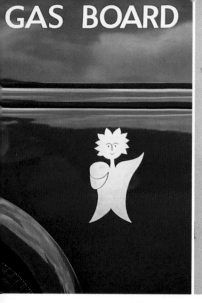

∧ **Wrotham** KENT

Mr Therm was a cartoon flame designed in the early 1930s for the Gas, Light and Coke Company by the illustrator Eric Fraser. After an initial fee of a fiver Mr Fraser received a mere £25 for all subsequent usage. Public service vehicles once had liveries that exuded confidence and authority (remember GPO Telephone vans in a deep bronze green?). The appearance of Mr Therm on this Fordson South Eastern Gas Board van must have brought a little levity to the serious business of fitting cookers and finding gas leaks.

⌐ The rear doors of a Morris J2, the local delivery van perfect for going to pick up a new alternator or a set of tyres.

46

Uppingham RUTLAND

'Amusement Caterers On Tour'. Fairgrounds give us many prizes in the form of bold, brash and colourful letter styles. The folk art influence has always extended to the vehicles used for moving dodgems and waltzers around the country, but it was once a common feature on all trucks, a style that's slowly disappearing from our roads as 'haulage' becomes 'logistics' and huge trunkers become mobile poster hoardings. A handful of transport companies still fly the flag, most notably the colourful big-shadowed lettering of a well-known Carlisle transport company with a cult following.

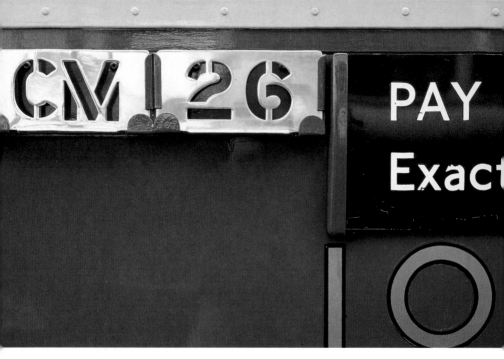

Wrotham KENT

London Transport once thoughtfully painted the buses used on rural routes
in a complementary shade of green with cream detailing – as synonymous
with the Home Counties as a parade of mock-Tudor shops and roadhouse
pubs on a by-pass. This photograph shows another delightful detail, the
movable stencil cut-out chrome letters and numbers that denoted its garage
(in this case Chelsham) and the direction of its route.

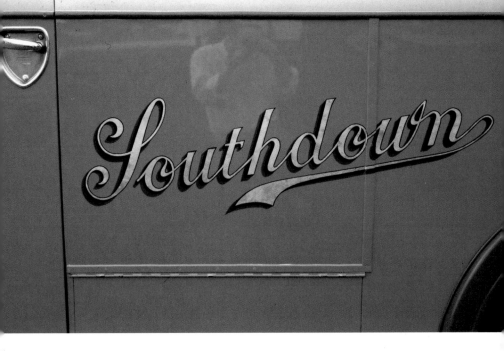

Wrotham KENT

This two-tone green and gold logo is guaranteed to make those who enjoyed holidays in post-war southern England go misty-eyed with nostalgia. Models of Southdown buses and coaches, with this glorious script like an autograph, are always in great demand: miniature reminders of hot lunchtimes at Victoria Coach Station and cool evenings in Sussex-by-the-Sea.

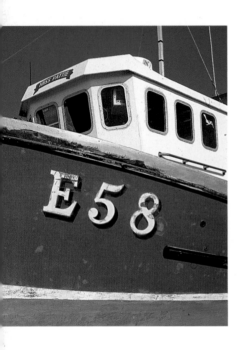

< **Lyme Regis** DORSET

'Miss Pattie' pulled up for maintenance next to the Cobb in Lyme Regis, the painted registration number in distress from the rigours of a tough life plying the English Channel.

> **Dungeness** KENT

Smaller fishing boats, like this one hauled up on the shingle of Dungeness, still show the pride of their owners with bold letter styles for the often emotive names and registration numbers. 'RX' is the code for Rye in nearby Sussex.

> **Gas Street Basin** BIRMINGHAM

The canal system offers innumerable opportunities to appreciate the art of narrow boat signing. The most individual painting of boats was the preserve of the 'No1's' or independent boat owners, the big cabin panels providing broad areas for unmistakeable names and the folk art of 'Castles & Roses' decoration.

RX 54 GRATITUDE

Nº.

198

JOSA

NAN

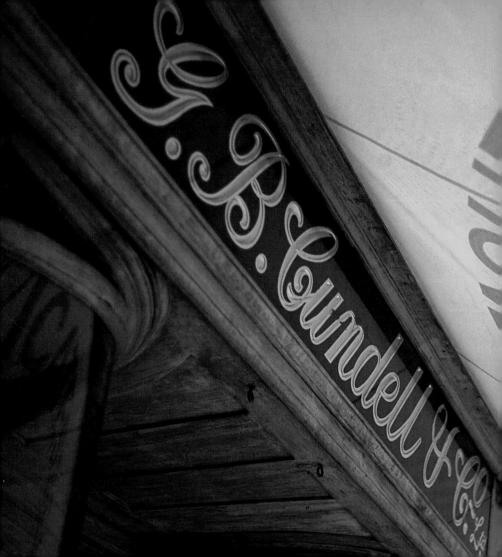

shop talk

Lettering proliferates in the retail environment. From the smallest paragraph of type on a packet of tea to a bold fascia at street level, letters are marshalled into line to communicate countless messages to the customers. My comments in the introduction about the transition from computer presentation to real life are sadly all too often illustrated in this area by the relentless robbing of local character by the marketing strategies of chain stores. Do we really want all our town centres to look the same? Shouldn't the integrity of differing building styles be respected? There was a time when this happened automatically, but sadly today the imperative appears to be to mass-produce signs in as great a number of common sizes as possible. Commercial sense, mediocre high streets.

Dartmouth DEVON
Cundell's is the kind of shop that has metamorphosed from humble grocer to purveyor of so many good things it's best not to go in there feeling hungry. It all starts out here on the pavement, with not only a gilded script run out on the reverse of a glass panel but also an emphatically-lettered sun blind.

< **Oundle** NORTHAMPTONSHIRE

Still on the wall, and although now sadly struggling to give an accurate account of the weather (who can?), nevertheless still managing to induce wan smiles at its main message.

> **Ramsey** CAMBRIDGESHIRE

Many fascias live on when some of the goods and services are no longer provided. J Freeman & Son isn't a tobacconist now, but I'm sure no-one would begrudge them the retention of these gilded letters set behind glass.

> **Dartmouth** DEVON

I almost think there's a kind of West Country vernacular about this newsagent's fascia, but I'm not at all sure what it is. Perhaps it's the air of solid unfussiness. In a narrow street these white-painted cut-out letters not only have great impact, but also give the appearance of having been finely chiselled out of the red background.

N & SON TOBACCONI

W. G. PILLAR
NEWSAGENTS

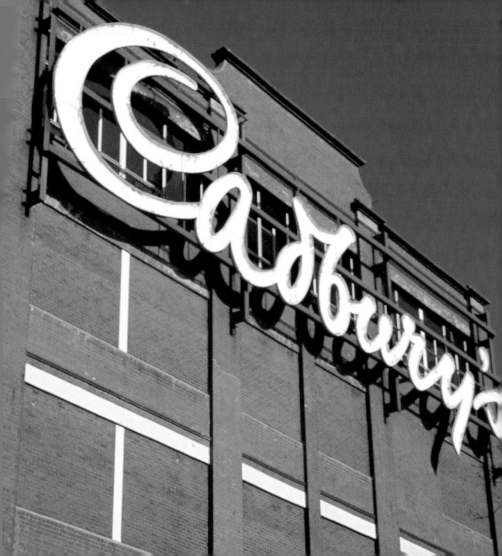

trade marks

We are all used to seeing the logotypes of household names dominating the products we buy. They are familiar elements on packaging and advertising, but sometimes they can appear in our environment when we least expect them – high up on walls, out across fields and at the side of railway lines. Occasionally they will appear in forgotten styles that trigger memories, but always they have the power of constant exposure that means that we instantly recognise them as we do pictures rather than words.

Keynsham BATH AND NORTH EAST SOMERSET
Look across the fields on the A4 between Bath and Bristol and you will see this giant logo written across the landscape, just as eye-catching as a chalk white horse on a hill. This is Cadbury's Somerdale chocolate factory, and a reminder of the days when the brand name did indeed have an apostrophe before the 's'.

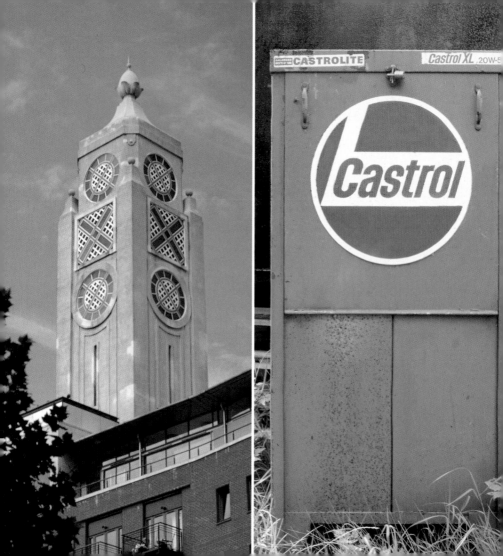

< **Southwark** LONDON SE1

Advertising restrictions in 1928 meant that Oxo were refused permission to put a large logo on the side of their new warehouse tower in Southwark, so architect A W Moore cleverly designed the windows to do the job instead.

< **Leicestershire**

Hump-backed dispenser cabinets like these once stood outside garages where boiler-suited proprietors would check your dipstick and if necessary fill a metal jug with oil. This simple version of the Castrol colour scheme and logo was once synonymous with post-war motor racing, where those of a certain age and disposition will recall the ghosts of speeding BRMs and Vanwalls being realised in skeins of exhaust and the scent of the curiously vegetable-smelling Castrol R.

> **Turogshire**

I've forgotten exactly where I was, but it was in the North. Wherever it is it's the perfect example of two logos for the price of one.

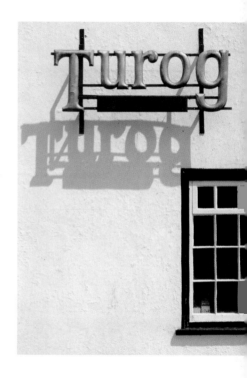

59

WILL's
STAR

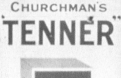

CIGARETTES

CHURCHMAN'S
TENNER

THE CIGARETTE
THAT SATISFIES

PRIVATE

DUNLOP
STOCK

DUNLOP

TYRES

E R

RECRUITS
ARE NOW WANTED
For all Branches of
HIS MAJESTY'S ARMY.

God Save the King.

any RECRUITER or to the nearest POST OFFICE. APPLY TO

WILL's
GOLD FLAKE
CIGARETTES

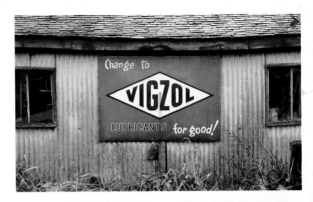

< **Norfolk**

Before the screwdrivers of 'street Jewellery' collectors got to work, these colourful patches were ubiquitous on shop walls, end gables, railway stations – indeed anywhere where a flat surface provided an advertising medium. Vitreous enamel signs grew so much in popularity that restrictions were placed on their use, but many survived to remind us of how eternal brands must have been perceived for this degree of permanence to be brought to their promotion. Many were later found doing duty as allotment shed walls, still mumbling their rusty messages amongst the courgettes.

⌐ **Leicestershire**

I wonder if anybody is still lubricating with Vigzol.

> **Sheffield Park** SUSSEX

Beautiful survivors from the steam age. These enamel signs on a railway platform also show us that cigarette pack design was once a glorious art. We will never see the like of these Woodbines and Gold Flake classics again.

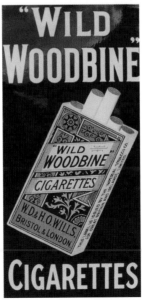

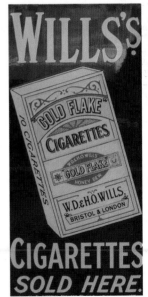

assorted alphabets

The sheer variety of signs is limited only by materials, letterforms and the skill of the craftsmen who interpret the designs. I have photographed them for over 30 years and it was relatively easy to sort them out into convenient chapters for this book. But inevitably there's a stack of images left over that defy such simple pigeon-holeing. As I sifted through them I realised that many of them are favourites, not just because of the signs themselves but also often because their discovery was unplanned: the happy results of taking short cuts, looking at the familiar in unfamiliar circumstances and heeding the first lesson in sign appreciation: 'Always Look Up'.

Chappel ESSEX

A perfect example of stumbling across a treasure when you're doing something else. Looking for a different view of the immense railway viaduct at Chappel I found this decaying sign on a bend in the road. I find it very pleasing for two reasons: that it is a survival of the once very common practice of forming letters in little reflective studs that caught car headlights like cat's eyes, and the gentle sounding nature of the business being advertised.

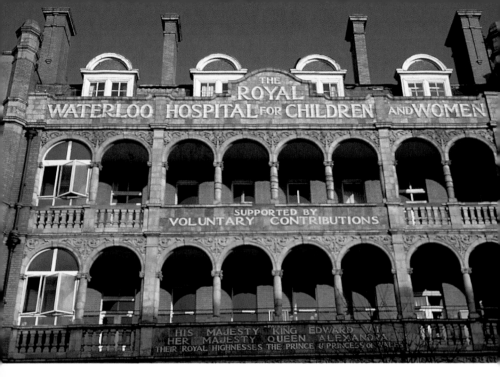

THE
ROYAL
WATERLOO HOSPITAL FOR CHILDREN AND WOMEN

SUPPORTED BY
VOLUNTARY CONTRIBUTIONS

HIS MAJESTY KING EDWARD VII
HER MAJESTY QUEEN ALEXANDRA
THEIR ROYAL HIGHNESSES THE PRINCE & PRINCESS OF WALES

Lambeth LONDON SE1

The *London 2: South* volume of Pevsner's *Buildings of England* series tells us that this remarkable former hospital building, completed in 1905, is in the 'Lombardic Renaissance' style, but doesn't mention the lettering, which surely is as much a feature as the 'three tiers of terracotta *logge*'. Each letter is formed from individual tiles, very likely by Royal Doulton whose nursery rhyme panels were a very welcome feature of children's hospitals in the early 20th century.

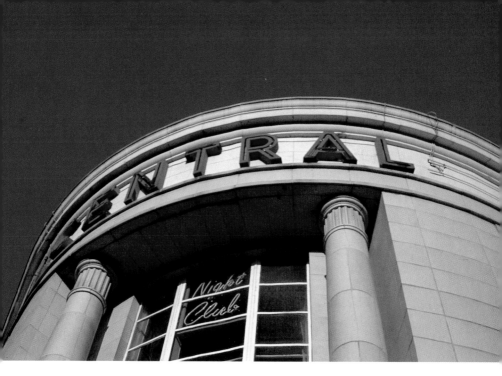

Stamford LINCOLNSHIRE

The sign in the window betrays a new use, but at least the Central still looks like a cinema. I expect there were murmurs of discontent in some quarters when this flashy piece of art deco appeared in Georgian Stamford, with its red metal letters glowing with inset neon.

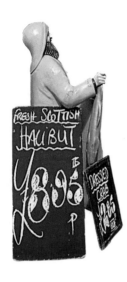

< **Nantwich** CHESHIRE

These almost life-size figures are becoming increasingly popular. We have jolly moustached butchers, gingham-hatted chefs and oil-skinned fisherman, all beaming fibreglass smiles at us in streets and on the roadside. I think it's something we've always done, images of our culture pushed out to gain attention like the carved figureheads of old sailing ships. Perhaps we need to take care that the idea doesn't run away with itself, so that we end up with jolly moustached mobile phone salesmen and gingham-clad estate agents.

Here in Nantwich the fisherman not only waves a giant cod about but also props up blackboards lettered in fishmonger/greengrocer vernacular. Their impulsive announcements often come under criticism for their misplaced apostrophes, but I'd sooner that than have the day's catch printed out in Raffia Initials from a computer.

∟ **Oakham** RUTLAND

A reminder of when fireworks were not a covert under-the-counter purchase, this seasonal prompt in the form of a jolly Guy Fawkes in the Bertie Bassett tradition was brought out every year to stand on a street corner of Oakham's High Street.

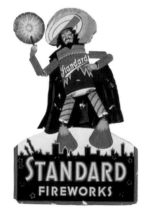

> **Cromwell** NOTTINGHAMSHIRE

Motorways and dual carriageways need landmarks to mark your progress. Too many stretches of new road are mind-numbingly and dangerously boring. The Great North Road still offers much to look out for, and here's one of my favourites between Newark and Retford: the unmistakeable red roof of the Cromwell Halt. Lettering on roofs enjoyed a post-war renaissance after being hastily scrubbed out so as not to provide too much help to the Luftwaffe.

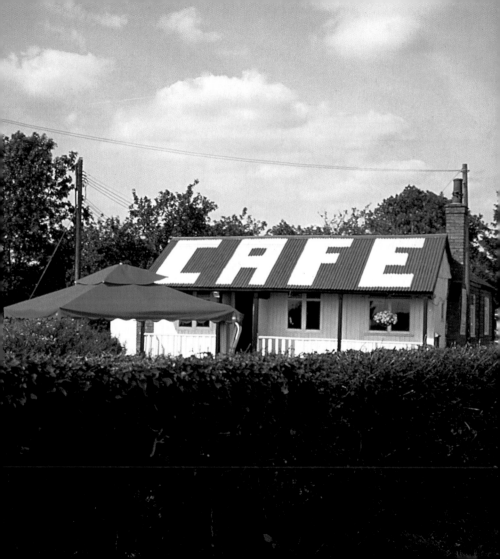

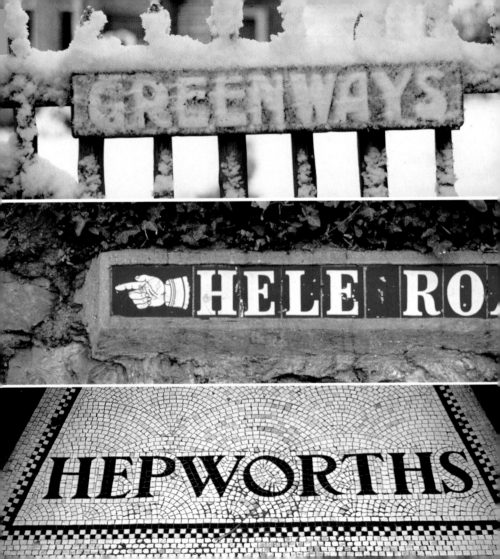

< **Hartley** KENT

A driving blizzard reshapes the art nouveau characters on an embossed tin plate house sign. The letter shapes are full of character, perhaps stamped Dymo-style out of the metal down at the local ironmonger – very refreshing after all those black cast-iron ovals for 'The Old Malthouse', 'The Even Older Post Office', etc.

< **Torquay** DEVON

Up amongst the laurels and ivy that hide the cottage ornée-style Victorian homes of Torquay is a street name in a Devon vernacular style of blue and white ceramic tiles. Another classic pointing finger gives directions. Individual tiles will very often have come from different kiln-firings, and so subtle variations of hue are always possible.

< **Dartmouth** DEVON

Look out for previous shop owners in the mosaics of entrance doorways. Most will have been ripped out by those zealous to stamp their new identity, but here in Dartmouth they still value these things.

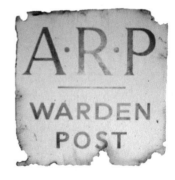

Luccombe ISLE OF WIGHT

A true survivor, a little plate marking the position of an Air Raid Precaution post, up on the cliffs on the south east coast of the island.

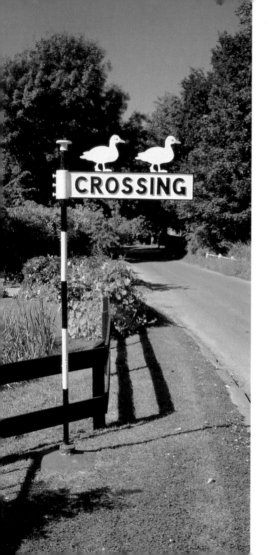

< **Ludham** NORFOLK

Ducks in Ludham should be proud of this locally made sign, erected by the pond for their safety. It's a delightful combination of the original black-and-white national road sign style, even using three-dimensional letters, and children's book cut-out ducks.

↘ **Mareham-le-Fen** LINCOLNSHIRE

These are the last vestiges of a landmark garage on the A155 between Sleaford and Skegness. Gosling's extensive range of green corrugated iron buildings stretch out along the road, and one last piece of pre-war advertising still clings on to the side, a once illuminated box sign.

Hertford HERTFORDSHIRE

The bold lettering here even gets a mention in the Hertfordshire edition of Pevsner's *Buildings of England*. The Green Dragon Hotel folded its last napkin in the mid 1970s, and I expect the last horse clattered out on the cobbles somewhat earlier. This 1903 Dutch gabled wall is faced in terracotta, with its menu of services picked out in gold. 'Motor Pit' is so redolent of the era, with motoring just getting to grips with the dusty highways. I expect the pit was in constant use (Napiers and Darracqs spluttering up the Great North Road); Edwardian motorists must have spent more time flat out underneath their motor cars than sitting upright driving them, and I hope Hertford will look after this wall in memory of them.

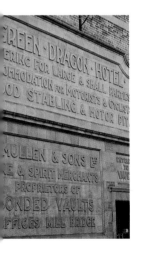

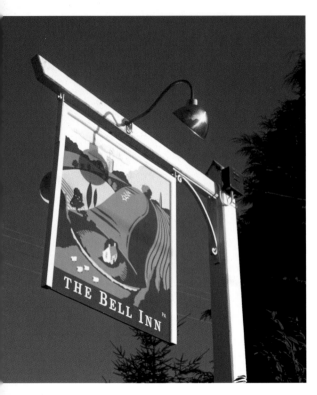

East Langton LEICESTERSHIRE

A lot of thought and care went into this sign, with a signwriter following the design religiously, right down to the last church tower and field furrow. The countryside around the Langton villages shifts and turns to form a bell; a farmhouse becomes the clapper and a garden wall metamorphoses into the bell's rim. Even a flock of birds flying down a grassy field becomes a reflective highlight in the bell's surface. This is the traditional sign painted as an optical game.

But we live in a time when, sadly, salmon fishcakes and sancerre are more important elements in pub life than a sense of place, so this sign was destroyed by being painted over. I suppose this photograph may be the only surviving record.

Southwold SUFFOLK

Two voluptuous mermaids are employed in a Southwold side street to grace a particularly handsome sign, one to point to the letters and the essential scallop shell and the other to show the way in.

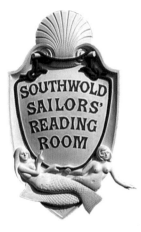

Ramsey CAMBRIDGESHIRE

Old building, new uses, but at least in Ramsey they recognised the appeal of the sand-blasted glass doors and preserved them for future generations. This treatment of the glass fulfils different functions: it acts as a privacy device, used extensively in public houses and railway stations (see page 31), and is perfect for leaving areas clear for lettering and decoration whilst still allowing light to pass through.

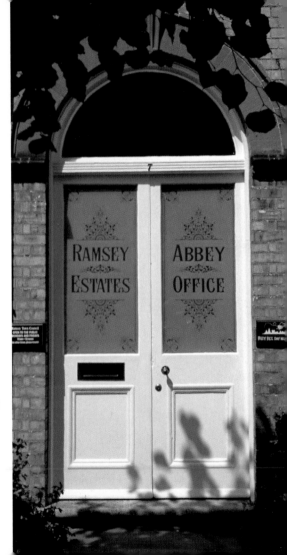

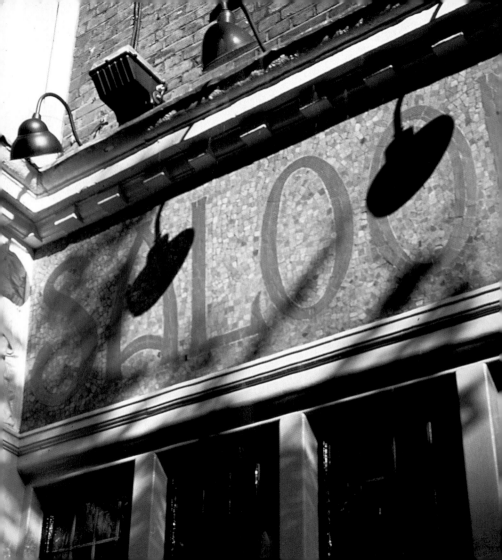

The Black Friar LONDON EC4

Pevsner called this '...the best pub in the Arts and Crafts fashion in London.' And so it is, with pink veined marble bars and Black Friars telling stories around bronze friezes. And that's just on the inside. On its wedge-shaped site on the corner of New Bridge Street and Queen Victoria Street the 1905 exterior displays more stunning decoration, with a mosaic fascia forming the background to superb gold enamelled letters.

Architect H Fuller Clarke and sculptor Henry Poole drew their influences from the fact that the area was once occupied by a Dominican monastery, and I've always been appreciative that brilliant artistry and craft have been harnessed to bring us messages such as 'Worthington Ales on Draught.'

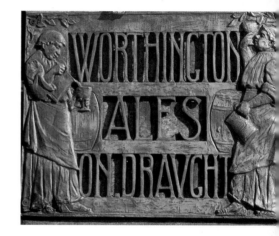

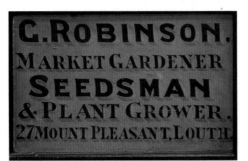

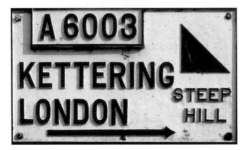

L **Louth** LINCOLNSHIRE

The alphabet is freely interpreted on a delightful sign in Louth market. I don't know how old it is, but certainly it wouldn't have been out of place here in the 1890s. Louth has many fine lettering examples, from heavily-engineered street signs to hand-lettered trade boards like this, all of them preserving a continuity of quality in a town at the centre of an agricultural community.

L **Uppingham** RUTLAND

This cast-iron sign could once be seen at the back of an ironstone building in the Market Place, probably put up in the 1930s. It would have been taken down during the war and erected again afterwards. It tells you what town you'll find on the A6003, which direction it is and the fact that you'll have to take care down a very steep hill first. All these facts are still true in 2004, but of course it's disappeared because its rugged no-nonsense style has no place in the Euro Corporate Identity Manual of Daily Life. Along with mileposts I think we should start listing all traditional signposts that still exist in their original positions.

> **Great Yarmouth** NORFOLK

The remnants of torn-off posters are untidy and scruffy, but nevertheless give us Schwitters-style collages in the most unlikely places. These fragments of lettering, revealed here on one of the pavilions to the Wellington Pier, are often more interesting than the originals.

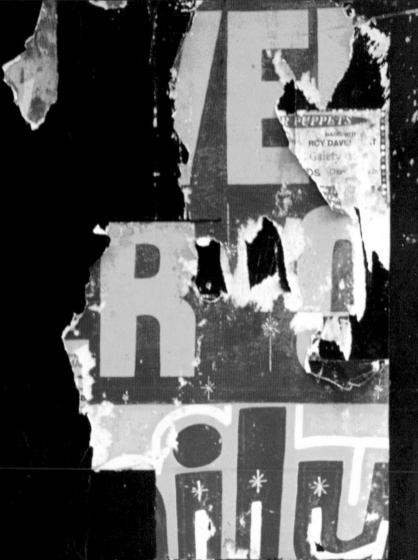

FRY'S
HIGH CLASS
CHOCOLATE

Cadbury's CHOCOLATE

ICES.

ICES

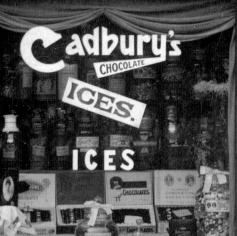

Cadbury's CHOCOLATE

ICES.

ICES

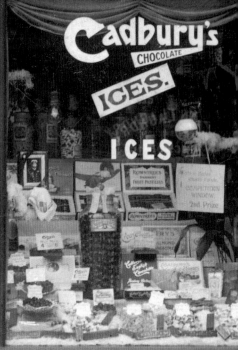

acknowledgements

I am particularly grateful to Jo Wood of The Sign Company, who shares my passion for these things and who has been a very understanding supporter of this book. I also owe a debt of gratitude to all those unknown signwriters who so accurately reproduced liveries on vehicles I photographed at transport fairs. Many thanks too, to: Val Horsler and Rob Richardson at English Heritage, Ian Taylor at London's Transport Museum, Sacrewell Farm Museum, Margaret Shepherd, Lucy Bland, Rupert Farnsworth and Biff Raven-Hill.

bibliography

Tombstone Lettering Alan Bartrum, Lund Humphries 1978
The English Lettering Tradition Alan Bartrum, Lund Humphries 1986
The Art & Craft of Signwriting William Sutherland, Omega Books 1987
Signwritten Art Tony Lewery, David & Charles 1989
The Moving Metropolis Edited by Sheila Taylor, Laurence King 2001
Designage Arnold Schwartzman, Chronicle Books 1998
Signs of the times Klaus F Schmidt, Graphis 1996
The art of looking sideways Alan Fletcher, Phaidon 2001

< **Flixton** LANCASHIRE

A c1910 confectionery shop belonging to Polly and Arthur McAlpine on the outskirts of Manchester demonstrates superbly the once common use of thin white-painted metal letters and logotypes to spell out messages on glass windows.

Overleaf:
Oundle NORTHAMPTONSHIRE

A brass letterbox for Oundle School Bursar's Office, with its own dripstone for weather protection.

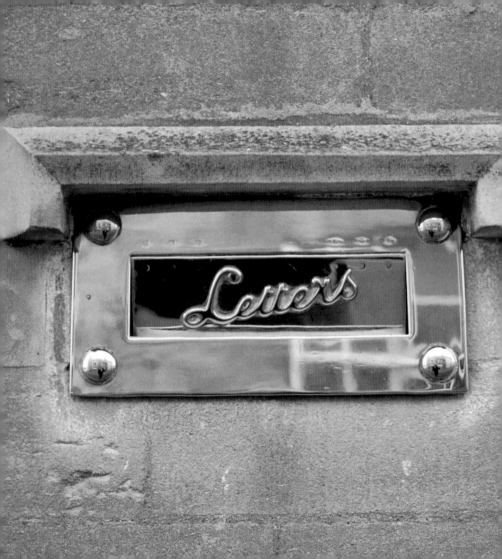